THIS IS
A BOOK FOR
PEOPLE
WHO LOVE

TATTOOS

THIS IS
A BOOK FOR
PEOPLE
WHO LOVE

VERENA HUTTER
ILLUSTRATED BY ERIC HINKLEY

RUNNING PRESS
PHILADELPHIA

Running Press
Hachette Book Group
1290 Avenue of the Americas, New York, NY 10104
www.runningpress.com
@Running_Press

First Edition: May 2024

Published by Running Press, an imprint of Hachette Book Group, Inc. The Running Press name and logo are trademarks of Hachette Book Group, Inc.

The Hachette Speakers Bureau provides a wide range of authors for speaking events. To find out more, go to www.hachettespeakersbureau.com or email HachetteSpeakers@hbgusa.com.

Running Press books may be purchased in bulk for business, educational, or promotional use. For more information, please contact your local bookseller or the Hachette Book Group Special Markets Department at Special.Markets@hbgusa.com.

The publisher is not responsible for websites (or their content) that are not owned by the publisher.

Print book cover and interior design by Jenna McBride.

Library of Congress Cataloging-in-Publication Data
Names: Hutter, Verena, author. | Hinkley, Eric, illustrator.
Title: This is a book for people who love tattoos / Verena Hutter ; illustrations by Eric Hinkley.
Description: First edition. | Philadelphia : Running Press, [2024]
Identifiers: LCCN 2023024752 (print) | LCCN 2023024753 (ebook) | ISBN 9780762485956 (hardcover) | ISBN 9780762485970 (ebook)
Subjects: LCSH: Tattooing. | Tattooing—Pictorial works.
Classification: LCC GT2345.H88 2024 (print) | LCC GT2345 (ebook) | DDC 391.6/5—dc23/eng/20230713
LC record available at https://lccn.loc.gov/2023024752
LC ebook record available at https://lccn.loc.gov/2023024753

ISBNs: 978-0-7624-8595-6 (hardcover), 978-0-7624-8597-0 (ebook)

Printed in China

APS

10 9 8 7 6 5 4 3 2 1

TO LEE, MY PARTNER IN ALL THINGS.

CONTENTS

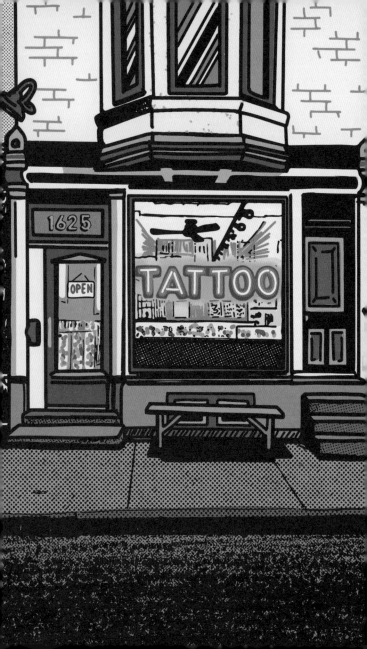

WHY WE LOVE TATTOOS

If you've picked up this book, chances are you are one of the over 30 percent of Americans who have a tattoo. Or perhaps you love someone who is tattooed, or maybe you dream of getting one.

With over 40,000 artists in the United States alone and the industry still growing, there are more styles, techniques, and colors from which to choose than ever. This book pays homage to what's sometimes called "old-school tattooing," "Americana," or "American traditional style."

This style is characterized by big, bold outlines made with a liner with multiple needles, heavy black shading, and a limited color palette—mainly the primary colors. Despite its seemingly simplistic, two-dimensional-looking style, do not be deceived: It takes skills to render the tattoos and their bold lines properly. The imagery of these tattoos is deeply influenced by the real-world experiences of those who were tattooed in the United States in the late 19th to early 20th centuries: sailors, soldiers, and show people of the circuses and sideshows. The designs can be nautical, patriotic, religious, or superstitious and

are sometimes combined with catchy slogans and life mottoes. They are a way to tell someone else who you are, as well as protect yourself on your journey. Each motif has its own meaning, when combined with another motif it may stand for something completely different.

A small caveat: You will find designs similar to American traditional style in other tattoo cultures, such as Great Britain or other European countries. Wherever there were sailors and port cities, tattooing was practiced. However, because of U.S. military and economic dominance in the 20th century—and the number of people practicing the craft—the style thrived and evolved here the most. And while your life may radically differ from those who got a tattoo in the Bowery in the 1900s, the meanings behind the motifs have remained the same. Tattoo artists practicing this style know they are part of a long tradition of misfits, craftspeople, storytellers, artists, and visionaries. The style is a tradition of sailors, workers, and servicepeople—those on the fringes of society, but still a vital part of it. These are just a few reasons why we love these tattoos.

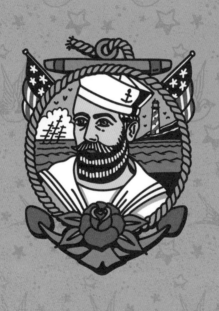

The history of tattoos runs parallel to the history of humankind. Ötzi the Iceman, a mummified corpse found in the Austrian Ötztal Alps and dating back to 3300 BCE, had approximately 60 tattoos. Most of them are thought to be medicinal—sets of vertical or horizontal lines placed on his lower back and joints. Researchers assume that the tattoos either marked acupuncture spots or that they were supposed to have a healing or pain-alleviating effect. In 2019, researchers found tattoos on 3,000-year-old Egyptian mummies as well, although the significance of the tattoos is still up for debate—they could be religious or medicinal. Scholars assume that tattooing may go back even further in history, but that is difficult to prove unless older tattooed human remains are found.

In ancient times, tattooing often was a punitive practice. Roman emperor Caligula is said to have had gladiators tattooed, as well as early Christians who were sent to labor in the mines. Among other ancient cultures, such as the Picts (from what is now Scotland) and the Thracians

(hailing from the eastern Balkan Peninsula), tattoos were status symbols.

In medieval Europe, tattooing was often associated with religion, such as with the Hiberno-Scottish monks who, according to contemporaries, had Celtic figures tattooed on their bodies to look as imposing and impressive as their Celtic counterparts. During the time of the

Crusades (1096–1291 CE), soldiers marked their bodies to ensure a Christian burial, but also got tattooed as a rite of passage. In Jerusalem, the Razzouk family has been running a tattoo shop since 1300. Now in its 28th generation, they own one of the largest collections of pilgrim tattoo symbols.

In the Americas, tattooing was also practiced among Native Americans, as can be seen on head-shaped effigy pots decorated with tattoos found in Mississippi and other artifacts and described in oral histories. There are also mummies from South America bearing tattoos.

All this goes to show that the practice is universal. Still, we can assume that it waxed and waned in popularity.

During the Age of Exploration (1400–1600s), when European powers set out to "discover" the rest of the world and expand their political and economic influence, they met tattooed Pacific Islanders for the first time. Captain James Cook (1728–1779)—a "thrifty Yorkshire man" to some, but a brutal colonizer to others—is credited with coining the term *tattoo*, deriving it from the Tahitian word for "to mark." While he called it a "strange practice," the ease with which his crew adopted it hints at a certain familiarity.

Over the years, the practice of tattooing became part of the discourse of scientific racism. It was considered an indicator of so-called atavistic or underdeveloped peoples. In the United States, missionaries operating on these assumptions tried to eradicate the tattooing that many Native American nations practiced. White people who got tattooed were either criminal, developmentally lagging, or forcibly marked. Despite these misguided attempts to eradicate it, the practice survived.

Traditional tattooing has been practiced in different ways in various cultures.

In general, the artist uses a manual tool—a tattoo needle. The needle can be made of any sharp material—bamboo sticks, bones, or metal—and is attached to a stick.

The artist dips the needle into the ink, pierces the skin, and then taps the ink underneath, in a quick, rhythmic motion, creating small dots and lines. Traditional Māori tattooers in New Zealand combine elements of the practice of scarification and tattooing, using a chisel-like tool to carve the design into the skin and then rub in the ink. While these techniques slightly differ, they are physically demanding of both the artist and the person obtaining their tattoo and can take days to finish, depending on the design.

The 1891 patenting of the first tattoo machine by Samuel O'Reilly revolutionized the process and changed the

world of tattooing forever. For a long time, tattooing in Europe and the nonnative Americas was done by hand, as well as with a metallic needle and ink. O'Reilly's tattoo machine was based on Thomas Edison's invention of the electric pen—a metal stylus, connected to two batteries, would puncture small dots into a piece of paper while writing on it. The punctured paper then could be used as a stencil to make copies of what-ever was written. O'Reilly added an ink reservoir, which deposited the ink through a tube as the needle pierced the skin. A motor or electromagnet was used to adjust the speed or depth of the needle.

O'Reilly's machine was a game changer, since it sped up the tattooing process. Quicker tattoos meant more people getting tattooed and artists being able to earn a living by tattooing. Charlie Wagner, O'Reilly's mentee, later improved the design, allowing for easier handling of the device. While traditional tattooing is still practiced and revered, most artists have moved to the electric tat-tooing machine.

The evolution of American traditional style tattooing runs parallel to U.S. history—it's a rags-to-riches story, one of many eccentrics, wars, and technological advances, as well as of being at the right place at the right time.

The Civil War (1861–1865) introduced the concept to many U.S. households. What earlier generations may have deemed "uncivilized" became a matter of practicality. Many soldiers on both sides had their names, their regiments, or important symbols tattooed on themselves so that they could be identified in case of their death, when uniforms and stripes could get lost. The commonality of tattooing during the war brought the practice to a broader audience. It was not uncommon for secret societies or "upper-class ladies" to have small tattoos—in places that clothes could cover. Tattoos at the time were still done by hand and with either black or vermillion ink. Martin Hildebrandt, who claimed that he had

tattooed thousands during the Civil War, opened the first tattoo shop in the United States as early as 1859.

The European immigration wave (1880–1920s) ushered in a new age for tattooing. The Bowery, an area in the Lower East Side of Manhattan, became a lowbrow amusement area, where Hildebrandt and other tattooers set up shop, sometimes in the back of barbershops. P. T. Barnum started exhibiting curiosities and other artists, and soon tattooed ladies—among them, Martin Hildebrandt's wife Nora—began to exhibit their artwork. Using invented tales of forced tattooing by Native Americans, tattooed ladies tapped into contemporary racist imaginations to sell their stories. The advance of print media made marketing their shows easier and earning a living as a tattooed performer possible. And when Samuel O'Reilly, another legendary Bowery tattooer, patented his tattoo machine in 1891, the craft was further catapulted into a new era. Tattooers now posted images of their designs, called "flash," in the windows or the doors of their shops as advertisement for their services. As tattooing became more popular, tattooers would also sell their designs, resulting in an archive of images that we now recognize as traditional style tattooing.

While circuses and sideshows decreased in popularity in the 1920s, tattooing continued thanks to two world wars. The connection between the armed forces and tattooing was as strong as ever, especially in the U.S. Navy and Marines. To be sure, the tattoos of the armed forces were no bodysuits, but more patriotic symbols were adopted and adapted as tattoos. Once military regulations instituted rules about tattoos—racist imagery and nudity were prohibited—tattooers found themselves with more business than before—often covering up previous tattoos.

In the repressed culture of the 1950s, tattooing grew polarized. While society tolerated military tattoos, otherwise tattoos were associated with deviance, gangs, and outsiders. In 1961, New York City prohibited tattooing, claiming it had caused an outbreak of hepatitis B. Tattooers were still operating, but on a much smaller scale and in secret. Other cities, such as Chicago and Detroit, also had a stable tattoo scene, but a large number of tattooers began to concentrate on the West Coast and in Hawaii—close

to military bases. San Diego, the Pike in Long Beach, and Honolulu became hot spots for sailors to get tattooed during their time off.

The civil rights movement, women's liberation, and the Vietnam War as well as the opposing peace movement marked a societal shift that also affected the tattoo world. Women—a previously neglected market segment—now wanted tattoos. Several tattooers campaigned for higher hygiene standards to make tattooing attractive to even more people. The wider visibility of tattoos in turn pressured artists to be innovative and elevate their game.

When Ed Hardy first offered appointment-only and customized tattoos and others followed suit, the scene began to diversify. While Hardy famously added Japanese elements to U.S. traditional tattooing, Chicano-style fine-line tattooing also grew in popularity. In the late 1970s and early 1980s, traditional Polynesian cultures experienced a revival, laying the groundwork for the popularity of tribal tat- toos in the 1990s. While some say that this made the popularity of old-school tattoos fade, they never completely

went away and have seen a resurgence in recent years. Just because something's old, doesn't make it bad.

Thanks to television, the internet, and other technological advances, tattooing is more diverse and active than ever before. And while there are plenty of styles to choose from, American traditional style, with its wild history, stark imagery, strong symbolism, and larger-than-life characters, will always be a beloved mainstay of tattooing culture.

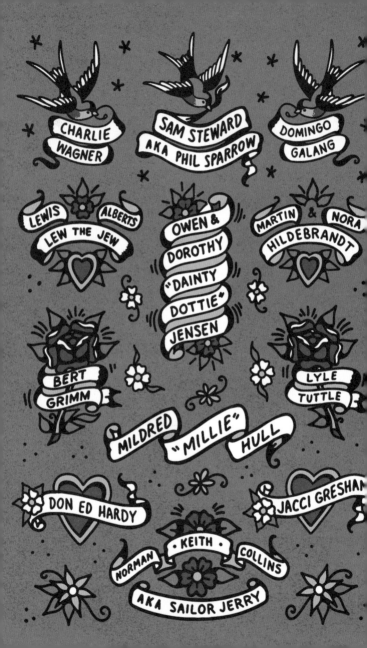

PROMINENT TATTOO ARTISTS

Until about twenty years ago, U.S. tattoo history was relegated to local historians, tattoo artists who wanted to preserve history, and a few aficionados. Since then, through the efforts of many, we know more of the rich history of prominent tattoo artists. They were a tight network of fierce competitors, businesspeople, artists, and storytellers, conscious of lineages—who was mentored by whom—and driven by a deep sense of honor and responsibility toward their customers.

Despite our increased knowledge, there is much about these artists' lives that is shrouded in mystery. This list can only provide a glimpse, for there are countless untold stories waiting to be unearthed, forever fueling our curiosity and hopes to uncover more about their remarkable lives and legacies.

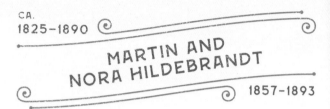

MARTIN AND NORA HILDEBRANDT

1857–1893

German immigrant, Martin Hildebrandt was probably the earliest recorded professional tattoo artist in the United States. He joined the U.S. Navy in 1846, where he learned to tattoo from a fellow sailor.

Hildebrandt served in the U.S. Civil War (1861–65) in the Union's Army of the Potomac, where he claimed to have tattooed thousands of soldiers, who sported tattoos both to show their allegiance and to be identified in case of death.

Soon after the Civil War, Hildebrandt opened his tattoo parlor in New York City on Oak Street, where he tattooed by hand, using black and vermillion ink. One of his greatest works, however, was the tattooing of his common-law wife Nora Hildebrandt.

In 1882, Nora Hildebrandt presented herself at George B. Bunnell's New American Museum in New York, a dime museum. Designed to entertain as well as educate the

working classes, dime museums contained curiosities and oddities and also housed performances of people with differences thought to be of interest to the viewing public. In many ways, dime museums were a stationary circus sideshow.

While Nora displayed her 365 tattoos, she told a story as wild as it was outrageous: Held in captivity by Chief Sitting Bull, she claimed to have been tattooed by her father—Martin—in exchange for their freedom. One of the earliest "tattooed ladies," Nora began to tour the United States and Mexico. We can assume that Nora's tale is also the source of conflicting narratives—in some sources she is listed as Martin's daughter, in others as his wife.

In 1885, while Nora was on tour, Martin found himself arrested for disorderly conduct and was admitted to the New York City Asylum for the Insane, where he remained until his death in 1890. Nora, on the other hand, married a tattooed barber named Jacob Gunther, and together they worked at a sideshow for Barnum & Bailey. Sadly, Nora died in 1893 at the age of 36.

CHARLIE WAGNER

Born in Prešov (in today's Slovakia), Charlie Wagner arrived in New York at the age of five and grew up on the Lower East Side. Wagner recounted seeing the tattooed attraction Prince Constantine at a dime museum, which led him to pursue tattooing. After training with Samuel O'Reilly, Wagner opened his own shop and, in 1904, patented an improved version of O'Reilly's tattoo machine. Upon O'Reilly's death in 1909, Wagner took over his famous tattoo shop located at 11 Chatham Square in the Bowery, where he also began a tattoo supply business. Wagner famously drew his tattoos freehand rather than using a stencil. Legend had it that he decided on a new motif to tattoo on a daily basis and that would be the only design he'd offer on a given day. He was also the first to offer cosmetic tattooing, experimenting with color pigmentation to achieve a natural look. Anthropologist Albert Parry relied heavily on Wagner for his 1933 book, *Tattoo: Secrets of a Strange Art*, and we can assume

that Wagner embellished some of his anecdotes—for example, when he claimed that several New York maternity wards had asked him to tattoo all newborns to avoid mix-ups.

One of Wagner's main income streams during WWII was covering up "indecent tattoos." When he found himself in front of a judge due to a sanitation code violation, Wagner declared that he was supporting war efforts by getting members of the armed forces ready to ship out. The perhaps somewhat contrived argument appeased the judge, and Wagner got off with a $10 fine and a warning to clean his needles.

Unfortunately, after Wagner died, most of his flash was lost, but the King of New York Tattooing has not been forgotten.

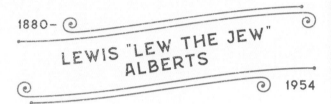

LEWIS "LEW THE JEW" ALBERTS

L ewis Alberts was the subject of many stories and myths. Born Albert Morton Kurzman in New York to Jewish German immigrants, Alberts attended the Hebrew Technical Institute to study wallpaper design and engineering. During the Spanish-American War (April 21–August 13, 1898), he was stationed in the Philippines where he learned to tattoo. Some sources claim that's where he developed a prototype for the tattoo machine, yet that narrative was never proven.

Upon his return to New York, he became business partner to Charlie Wagner and established his nom de needle of "Lew the Jew" in a nod to his origins. It was also a smart way to establish himself within the scene, as the short moniker was easily remembered by fellow artists and customers alike.

Perhaps the most important contribution to tattoo history in the United States was Alberts's decision to market

his flash to the public, which helped other artists, who—if they liked a design—often had to copy it from a customer or draw it from memory. Alberts was also in constant contact with tattooers based on the West Coast, such as Bert Grimm (see page 30) and Charlie West. According to Grimm, West sold Alberts his flash after a long night of drinking, and Alberts passed them off as his own. But with Grimm as the sole source of this story, we may never be able to establish its veracity. Even if the motifs had been pilfered, Alberts made them his own. He constantly improved on them, so much so that anthropologist Albert Parry declared in 1933: "That is why so much American tattooing looks like the walls of your grandmother's living room. Lew-the-Jew left his mark on the folk-art of America."

Alberts died in New Jersey in 1954. In 2015, Ed Hardy published *"Lew the Jew" Alberts: Early 20th Century Tattoo Drawings*, documenting and honoring Alberts's life and work.

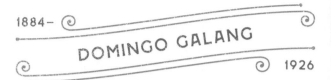

1884–

DOMINGO GALANG

1926

L ittle is known about Domingo Galang's childhood in the Philippines. What we do know is that after arriving in Hawaii in 1910, Galang worked on a sugarcane plantation on Maui.

In 1913, he relocated to Honolulu on Oahu, and he opened his first tattoo shop a few years later in 1917. Details about Galang's artistic abilities are spare, though Bert Grimm praised his shading techniques. With the growth of the U.S. military presence in Hawaii—two Army bases, an air force base and a Navy base—Galang's business thrived, and he added several partners over the years, including his nephew Valentine Galang. During a time of racial animosity, discrimination, and segregationist policies in Hawaii, being a successful immigrant business owner was no small feat; Galang achieved his own version of the American Dream. Tragically, Domingo Galang passed away in 1926 due to tuberculosis, but he left behind a small tattooing empire. Nephew Valentine

Galang continued the family business, training several family members, including his father-in-law, Bob Miller, and his brothers-in-law, Eugene and Al Miller. Upon his arrival in Hawaii in the early 1930s, Sailor Jerry also briefly worked for Valentine Galang. The legacy of Domingo Galang and his family's tattooing tradition continued to influence the world of tattooing, long after his passing.

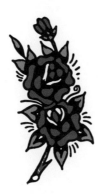

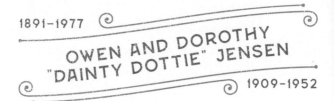

OWEN AND DOROTHY "DAINTY DOTTIE" JENSEN

orn and raised in Utah, Owen Jensen's first encounter with tattoos was at Buffalo Bill's Wild West Show in 1911. Two years later, he moved to Detroit, where he worked as a machinist for tattoo supplier J. F. Barber. Soon he began to learn to tattoo and later how to draw flash. Upon returning from WWI, he began to travel the country and settled in Los Angeles, California, in 1923. In 1929, he moved to Long Beach and opened a tattoo shop at the Pike, a famous amusement park along the beach. The West Coast got its first tattoo supply company when Jensen founded one in 1934.

A successful businessman, he worked with other influential and famous tattooers over the years. In 1976, he was attacked, stabbed, and robbed while working late at his shop. He never fully recovered from his injuries and died a year later. He is remembered for a long and successful career.

We know less about Jensen's wife Dorothy "Dainty Dottie" Jensen, even though she was a force in her own right and likely the largest female tattooer. Born Florence Sprague, she worked as a "fat lady" at the Ringling Bros. circus under the moniker "Dainty Dottie." We don't know how she first began tattooing, but she met Jensen when buying equipment from him. They married, had son Owen Jr. in 1949, and began working together, using her weight—585 pounds at the time—to advertise their tattoo parlor. Dottie died from heart disease in 1952. Even though her life was short, she made it memorable.

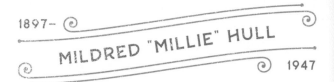

Mildred Hull grew up in the Bowery, though accounts of her life vary—including her own. After leaving school at an early age, she worked as an embroiderer, and found that the skills easily transferred to tattooing. Another account suggests a boyfriend convinced her to get tattooed and work as a tattooed attraction, but she then decided to do tattoo work herself. She learned the craft from Charlie Wagner, who taught and mentored many throughout his life, and began tattooing out of a booth in a barbershop at 16 Bowery, a setup not uncommon at the time.

While business slowed during the 1930s, Hull claimed that President Franklin D. Roosevelt's new Social Security program brought her new customers—up to 10 people a day wanted to have their newly issued Social Security number tattooed. Married to fellow tattooist Thomas Lee, Hull was said to be responsible for the majority of his over 400 tattoos, most of them religious images. Her

staying power in the Bowery—one of the roughest neighborhoods in New York at the time—spoke to her business talent and no-nonsense attitude.

Hull sadly took her own life, poisoning herself in the back of a tavern. According to some sources, she fought depression throughout her life; others suggest that a lover had drained her financially and then left her. A woman in a male-dominated business, Hull, who once referred to herself as "a sturdy little urchin from the word go," stood out as a pioneer, forging her own path.

orn in 1900 in Missouri, Bert Grimm would become one of the most prolific and recognizable tattooers of the 20th century. When he was 15, he began spending time at sideshow carnivals and later tattoo shops in Portland, Oregon, before moving to Chicago for a stint. After traveling with Buffalo Bill Cody's Wild West Show, Grimm opened his first studio in St. Louis in 1928. Despite the Great Depression, he persevered, and successfully ran his business for almost 30 years.

In 1954, he moved to Long Beach, California, where he set up shop at Nu-Pike, a revamped version of the old amusement park. A talented businessman with a strong work ethic, Grimm used photos of his tattoos as advertising material early on. He also took many young tattooists under his wing, among them Zeke Owens, Lyle Tuttle, and Ed Hardy, who remember him for his larger-than-life personality, charisma, and distinctive style. A gifted raconteur, he would often regale customers with stories from

his life and the many people he worked with throughout the years. Grimm settled back in Oregon in 1970, where he went in and out of retirement several times.

In recognition of his significant contributions to American tattooing, he was inducted into the Tattoo Hall of Fame at Lyle Tuttle's Tattoo Art Museum in San Francisco in 1981. After a nearly 70-year career in tattooing, he passed away in 1985, leaving behind a lasting legacy. His descendants now run the Bert Grimm Museum in Kansas City, preserving his influential contributions to the art form, while his great-grandniece, historian, and writer Carmen Nyssen, continues to honor his life and work.

In 1966, when tattooer hopeful Ed Hardy stepped into Phil Sparrow's tattoo shop, he was blown away. Instead of flash, Sparrow's walls displayed Japanese art, and the sound of classical music filled the shop. For Sparrow, tattooing was his second career, after he had quit his job as an English professor.

Born in rural Ohio as Samuel Steward, he attended Ohio State University and pursued a life in academia as a writer, professor, and even assistant to Alfred Kinsey. Feeling burned out, he decided to quit his career in 1952 and do something as far away from academia as possible— tattooing. He first enrolled in a long-distance correspondence course and practiced alone, until Amund Dietzel, a Milwaukee-based tattooer, took him under his wing. With this change in life came a new name—Professor Philip Sparrow. In 1966, Sparrow opened Anchor Tattoo Shop in California, and he later became the official tattooist for

the Bay Area Hell's Angel chapter. Hardy describes Sparrow as a "gay lone wolf in the tattoo world" and an intellectual who was not interested in connecting with other tattooers. Still, his influence on Hardy loomed large, especially Sparrow's encouragement to pursue his interest in Japanese art.

Sparrow retired from tattooing in the 1970s to pursue his writing career full-time. He published gay erotica and detective novels featuring his friend Gertrude Stein. In 1990, he released *Bad Boys and Tough Tattoos: A Social History of the Tattoo, with Gangs, Sailors and Street-Corner Punks*, based on his experiences, observations, and conclusions. While his psychoanalytical ruminations on why people get tattooed are rather outdated, Sparrow's detailed descriptions of the process, his customers, and fellow tattooers give us a glimpse into the day-to-day business of mid-20th-century tattooing. Sparrow died shortly thereafter in 1993.

Born Norman Keith Collins, the legendary Sailor Jerry began tattooing while "riding the rails" early on in his life, as he told it. In the late 1920s, Chicago tattooer Tatts Thomas taught him how to tattoo by machine, before Jerry moved to Hawaii and worked with Valentine Galang in one of the biggest local tattoo shops.

Soon Jerry developed an interest in Japanese tattooing traditions, and as early as the 1960s, he maintained correspondences with the Japanese artists Horihide, Horiyoshi II, and Horisada. As a result, Jerry incorporated aspects of Japanese tattooing—such as waves and clouds—into his Americana-style flash, making his work unique and easily recognizable. Fueled by a passion to advance American tattoo culture, Jerry carefully selected whom he mentored and corresponded with; one of his famous students, Ed Hardy exchanged letters with Jerry for years before he was allowed to visit him and learn. But Jerry's drive for

innovation went beyond artistic ideas. He insisted on sterilizing equipment and good hygiene long before the rest of the trade caught on, tinkered with tattoo machines to make them less painful, and experimented with non-toxic inks.

Yet he also cultivated a bit of a genius personality—Jerry had his own shortwave nightly radio show on which he dabbled in conspiracy theories, was vocal about other tattooers he deemed subpar, and according to Ed Hardy, indulged in an equal opportunity racism that "extended to everyone, but the Chinese."

After Jerry's death in 1973, Mike Malone, whom Jerry trusted with the keys to his kingdom, took over Jerry's shop. In the 1980s, Hardy and Malone began to publish books on Jerry's art, making him famous beyond the tattoo world. Hardy and Malone even partnered with marketing and advertising specialist Steve Grasse to found Sailor Jerry Ltd., in 1999, selling a series of merchandise featuring Jerry's designs, including Sailor Jerry Rum, a spiced rum with his famous Hula girl on the label.

LYLE TUTTLE

B efore Ed Hardy, there was Lyle Tuttle. Growing up in Northern California, Tuttle was 14 when he first got tattooed while on a trip to nearby San Francisco. It was a "mother" tattoo—a decision motivated by price ($3.50 was all he had) and the knowledge that his mother would have a hard time punishing him for it.

Like many tattooers of this generation, he began tattooing by hand, but by 1949, he was using a tattoo machine. Bert Grimm mentored him in his shop on the Pike, until he moved back to San Francisco to open his own tattoo parlor. Tuttle remembered being "at the right time in the right place," as the city in the mid-to-late 1960s saw the civil rights movement, women's liberation, the Vietnam War, and the resulting peace movement unfold. Lyle Tuttle read the signs of the time and seized upon the chance to introduce tattooing to a broader audience.

Many consider his tattooing of Janis Joplin—and her showing off his work on national TV—as well as his

subsequent *Rolling Stone* cover story as a turning point in tattoo history. Tuttle credited women's liberation as the factor for the rising popularity of tattoos, arguing that women—who previously had to get permission from husbands or fathers to get tattooed—now felt free to do whatever they wanted with their bodies. To be sure, his marketing savvy and engaging personality may have also been part of tattooing's mainstream rise.

Tuttle began collecting and chronicling tattoo history, opening a tattoo museum in 1974. Tuttle also pushed San Francisco to adopt stricter hygiene rules for tattooers, hoping to alleviate fears of needle infection and make tattooing respectable.

He retired in the 1990s but continued to appear at tattoo conventions, teach seminars, and occasionally tattoo his distinctive signature on friends and family. Tuttle passed away in 2019 from cancer. While some in the tattooing world were initially suspicious and perhaps even critical of his constant advertising, self-promotion, and the occasional yarn-spinning, it is undeniable that tattooing wouldn't be where it is today without his contribution.

ne of the most famous tattooers of the 20th century, Don Ed Hardy—who went by Ed—was born in Corona del Mar, California. Interested in art from an early age, Hardy attended the San Francisco Art Institute and graduated with a BFA in printmaking. Forgoing a scholarship to study art history at Yale, Hardy decided instead to pursue his interest in tattooing, having watched Bert Grimm in his shop on the Pike in his teenage years. He briefly was mentored by Phil Sparrow, who encouraged him to continue forging connections between Japanese art and tattooing. After he was invited to work with and learn from Sailor Jerry, Hardy moved to Japan in 1973 to learn traditional Japanese tattooing from artist Horihide. Combining traditional Americana tattoo motifs with Japanese imagery, Hardy developed his very own signature style, which he offered at his own tattoo shop, where he took the radical approach of setting up a custom and by-appointment-only operation.

Still, Hardy had a keen eye and interest in other traditions of tattooing. Over the years, he learned to practice Chicano style or fine-line tattooing and supported Leo Zulueta in his quest to popularize tribal tattooing in the 1980s. Moreover, Hardy worked to open tattooing to a new market segment—the middle class. In 1982, he launched *Tattoo Time*, a magazine devoted to the artistic aspects of the trade, instead of sensationalism or sleaze. In the same year, together with Ernie Carafa and Ed Nolte he organized a tattoo convention dedicated to elevating the networking and professionalism of the field.

Over the years, Hardy published several books to document U.S. tattoo history and celebrate various innovators in the field. In the early 2000s, he became a household name when he collaborated with designer Christian Audigier to produce accessories and clothes featuring his designs. Hardy has since retired from tattooing, but in 2013, he published his memoir *Wear Your Dreams: My Life in Tattoos*.

B orn in Flint, Michigan, Jacci Gresham is the first African American female tattoo artist. Even though there had been female tattooers, tattooing in the United States used to be a fairly white and male-dominated field. Gresham broke the mold. After studying architecture and engineering in college, Gresham began to work for General Motors in Detroit. In 1975, when Gresham and coworker Ajit Singh were laid off, they moved to New Orleans and opened a tattoo shop, Aart Accent. Gresham did not have any tattoos of her own and asked Ed Hardy to ink her first one. She quickly learned the craft and made a name for herself for "making ink look good on black skin." A part of her success might also be the shop's cheeky slogan: "Look better naked."

Gresham worked at Aart Accent for over four decades, until 2022, when she announced she was closing her shop. Along with coauthor Sherry Fellores, Gresham has penned a memoir about her life's work.

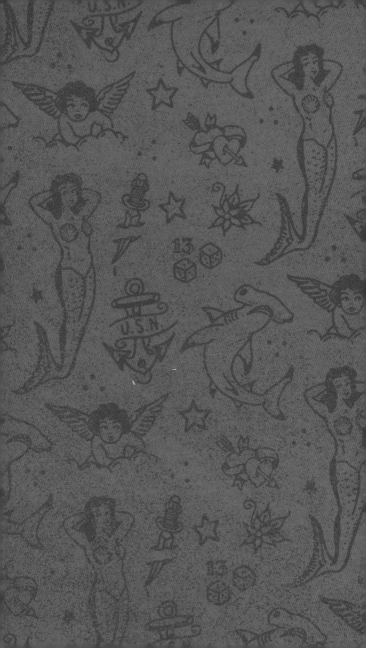

American traditional tattoos and their symbolism are rooted in the everyday experiences of their wearers. If you were a sailor, getting a tattoo with an anchor or a sailing ship reflected your life. An anchor tattoo, for example, expresses its wearer's hope for stability. A lot of the tattoos are also superstitious; they are symbols of luck and possibility. At a time when life at sea or in the military was full of dangers, a little extra luck could go a long way for an individual. While the American traditional tattoos may look simplistic, one of their most fascinating qualities is their versatility. You can combine so many different tattoos and tweak their meanings to express your unique position in life. Here are the most beloved and significant motifs and symbols of the style.

BIG CATS

Big cats—such as black panthers, tigers, leopards, and lions—are an all-time favorite of traditional tattooing. Revered in many cultures, these powerful felines stand for strength, ferocity, and trust in one's instincts, in addition to being connected to sexuality. However, their individual meanings all differ slightly.

The term *panther* is a catchall for big cats, including leopards, jaguars, and cougars. The **black panther** is a melanistic variation of the leopard, producing a dark, black-looking coat. As a jungle cat, it is a symbol of ferocity, power, speed, and independence. The classic striking panther tattoo has two possible origins: It is featured in writer and illustrator Marie Schubert's 1934 book *Minute Myths and Legends*, from which it found its way to tattoo flash. Another striking panther illustration, however, appeared in 1932 in a *Vanity Fair* magazine ad, drawn by illustrator Karl Godwin. We have no way of knowing whether Godwin's image might have inspired Schubert.

Tigers are featured in many myths and stories in their natural habitat in Asia. A solitary, yet social predator, they symbolize might and beauty, but also danger. In traditional tattooing, **tiger tattoos** often are similar to black panther ones, except for their coat. As with the panther, tattoos of striking tigers tend to be the most popular, but a calm and relaxed tiger exudes quiet confidence, sending a message of "don't underestimate me."

Lions—one of the biggest species of cats and the mythical head of the animal kingdom—have been a

regal symbol of nobility in Europe, Asia, and Africa since ancient times. They represent fearlessness, but they also stand for fierce protection; a lion will protect its pride. With a lion tattoo, you're telling the world that you'll protect your loved ones and that you're loyal, but also a leader.

Whichever big cat tattoo you get—or possibly all of them?—let them hear you roar!

BIRDS

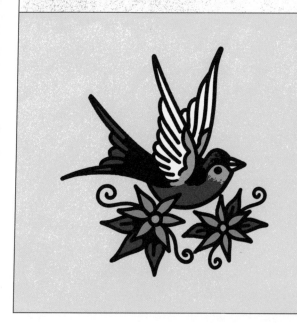

High in the sky, birds stand for freedom, and their cheery presence is uplifting. For sailors, swallows or bluebirds also were a literal symbol of hope, as they indicated that land was near. Swallows and other migratory birds signify good luck on travels, as they always return home no matter how far away they wander. On a more

somber note, some also believe that birds carry the soul of a deceased home.

Their positive and cheerful symbolism is also reflected in the strong, happy tattoo colors, such as blue and red or yellow. In some seafaring circles, a swallow tattoo meant that the sailor had traveled 5,000 nautical miles; two swallow tattoos—often placed on opposite shoulders—meant 10,000 nautical miles of travel.

The **sparrow tattoo** was also a symbol of freedom for prison inmates. As a sassy bird that often stands up to those much bigger than it, a sparrow as a tattoo reminds us all to stick up for ourselves and live in the moment.

Two **birds with a banner** and the name of a loved one on it show deep loyalty and devotion to your person—like the migratory birds, you'll always return to them.

The combination of a **swallow and anchor** is also a beautiful way to signal your steadfast nature, and it can work like a protective charm; regardless of how stormy the waves of life are, you're undeterred.

Less common are tattoos of **doves with an olive branch**. Both a religious and a secular motif, the dove tattoo is a sign of your faith or your love of peace.

EAGLES

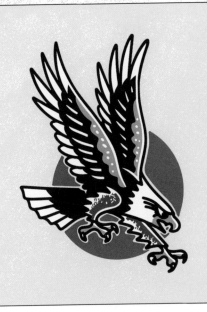

With a history spanning from ancient Rome to today and mythologies from Native American to Celtic, the majestic eagle is the king of birds, occupying a unique place in the world of tattooing. While there are 60 different species of eagles worldwide, the bald eagle is only found in North America. Adopted as the national emblem in

1782—much to Benjamin Franklin's chagrin as he had favored the turkey—the bald eagle stands for strength, independence, and universal and yet deeply American values. However, it also stands for dominance and tenacity; it is an apex predator after all!

As a tattoo, the style and size foreground which aspect of the eagle is important. The most famous style is of course the eagle with wings spread, swooping down, talons ready to claw, as it strongly and ferociously pursues its prey. A sitting eagle, on the other hand, looking proud and regal suggests confidence and watchful attentiveness.

Unsurprisingly, eagle tattoos are often used to express patriotism, especially when combined with other elements, such as flags, banners, or military emblems. Between the world wars, which was the golden age of the traditional tattoo, the eagle served as a reminder of what the soldiers were defending overseas—the universal freedom of humankind. After 9/11, eagle tattoos both traditional and realistic were in high demand. The symbolism of strength and tenacity over time has also been appealing to others, such as bikers, as well as really just about anybody who loves to roam.

OCTOPI

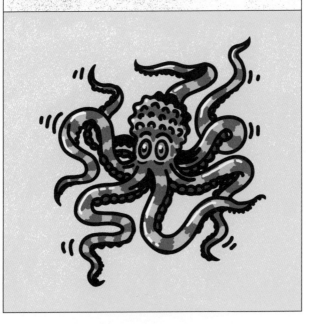

Octopi are some of the most enigmatic creatures of the sea. Living deep underwater, they usually avoid humans, which is why they are such a sensation when they show up. Their squishy shape and eight arms have given rise to many imagined creatures of the sea, such as the Kraken, a mythical sea monster off the coast of Norway.

Whether the octopus tattoo is inspired by myth or reality is impossible to trace. Some people will get an octopus tattoo because they love the intelligence of these creatures. Because some octopi kill their prey by releasing venom from their arms, octopi tattoos can also be a warning and a sign that you mean business. Dramatic tattoos, such as an octopus wrapped around an anchor, can express duality—staying grounded and strong while being curious and putting out feelers in different directions.

SHARKS

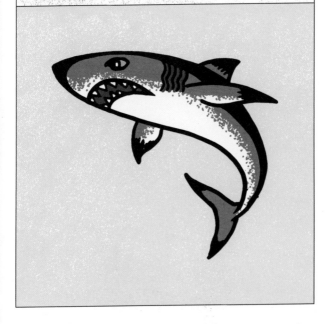

Sharks can be found in every ocean and come in every size. There are over 500 species of shark, some of which are apex predators. Sharks play an important role in Hawaiian and Samoan cultures, where they can be an embodiment of the ancestors' spirit. In modern popular culture, sharks unfortunately have been portrayed negatively, such as in

horror films or in a children's song about a family of sharks that shall not be named.

Shark tattoos usually feature the shark emerging from the water, displaying its sharp teeth. Sharks are quick, move elegantly, and as efficient killing machines, they are a fearsome, yet formidable foe. A shark tattoo affirms its wearer will stand their ground; it's eat or get eaten. For sailors, shark tattoos were about the daily danger that their lives entailed and symbolized facing their fears.

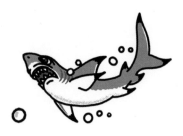

SNAKES

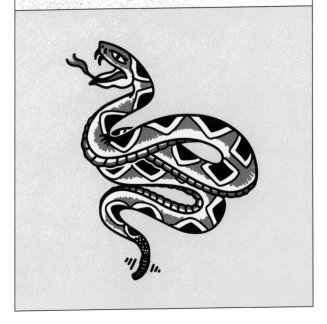

From the Christian symbol of temptation to Nordic, Indian, and African myths, snakes have been part of the lore of many different cultures. Shedding their skin regularly, they have been a symbol of renewal and transformation. Similarly, the symbol of an ouroboros, two snakes biting each other's tail, symbolizes the cyclical

nature of life, suggesting the eternal cycle of creation and destruction.

They have been associated with sexuality, fertility, and healing, for example in the Rod of Asclepius. However, they can also signify death, danger, and deception, embodying a sense of caution and mystery.

As a traditional tattoo, snakes are often connected to other tattoos, such as the dagger, but they can also stand alone as powerful symbols. Coiled up and ready to strike, they convey a "don't tread on me" attitude, serving as a warning to not underestimate or challenge you. Sailor Jerry is said to have favored inking king cobras, showcasing their menacing fangs and emphasizing their power.

In traditional tattooing, snakes may also symbolize protection from the very evils and dangers they represent, acting as guardians or talismans against harm and misfortune.

BOXERS

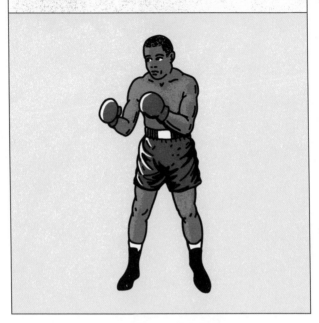

While brawling is as old as time, the first recorded rules for boxing originated with the Marquess of Queensberry in 1867. Because of the sport's strict adherence to rules, the respect for one's opponents, and the hard training boxers undergo—as the montages in *Rocky IV* taught us—boxing is seen as a gentlemanly endeavor.

The boxer tattoo reflects that quality. Depicted in 19th-century style, with a figure with parted hair, a moustache, sometimes a black eye and/or tattoos, the boxer is in many ways the male equivalent to the pinup girl. As an idealized version of masculinity, the boxer is a tattoo for those who face the struggles of life in a fair, stoic, and disciplined manner.

As the Rocky Balboa and Adonis Creed franchises and real-life boxing legends like Muhammad Ali and the Klitschko Brothers have shown, even though boxing is a gentlemanly sport, you do not need to come from riches to possess its ideal qualities.

The boxer tattoo symbolizes courage, fierceness, and self-control. Whatever life throws at you, you know you can take and land a punch.

DAGGERS

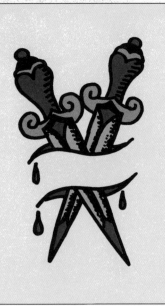

A useful fighting knife for direct combat since the age of antiquity, daggers are still part of the kit of several armies in the world. Easily concealed, they were the weapon of choice for assassinations.

The dagger can stand for courage and bravery in combat, yet it can also mean deception and duplicity. To some,

daggers are also a symbol of warriorhood and manhood, both because of their phallic shape and, probably more likely, because being able to handle a dagger used to be part of coming-of-age.

As a tattoo, the dagger is rarely by itself, which opens up almost endless possibilities for combination and symbolism. A few of the most common matchups include:

A **simple dagger with a banner** carrying a motto is striking and self-explanatory. One of the most famous dagger and banner tattoos is "death before dishonor." Or to show off your fighting spirit and strong moral compass, "to thy self be true" will signal you go your own way!

A **tattoo of a dagger through a rose** or sometimes behind a rose creates a strong contrast. The rose as the symbol of love and vitality juxtaposed with the dagger powerfully depicts the ups and downs of both love and life—or the possible betrayal in love.

Is there a stronger symbol for heartbreak or grief than a **dagger through the heart**? As with many traditional tattoos, people choose to wear this tattoo as a protection from exactly what it represents—pain and loss—but you can also wear it in memory of a loved one.

Not for the faint of heart, the **dagger through an animal skull**—wolves, lions, panthers, etc.—might feel gruesome and archaic; other than in direct combat, you wouldn't be able to kill a predator like that, and even then, it would be a production. Symbolically however, a tattoo like that stands for overcoming danger, seemingly unsurmountable challenges, and fears.

A **snake wrapped around a dagger** is another classic variation of the dagger tattoo. It can show the balance of good and evil or the need to protect yourself from danger. Alternately, you're letting the rest of us know you're not to be trifled with since you may strike back.

HANDSHAKES

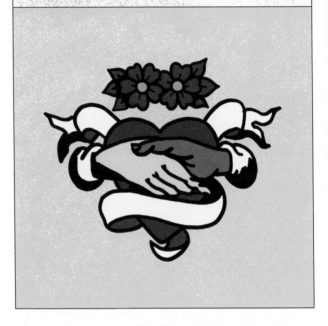

The handshake is one of the most common gestures in the world, but its origin is unclear. What about the union of two hands is so universal? Historians theorize that handshakes were a way to show peaceful intentions between people or to seal a promise made in good faith—just like they are today. Neurochemists also suggest that

during handshakes, social chemical signals are exchanged between shakers.

The traditional handshake tattoo looks similar to European fede rings, which feature two hands. The most famous of these, of course, is the Irish claddagh ring. Often used as filler between larger tattoos, the handshake tattoo is highly versatile and can have many variations, each with its own symbolism.

The **traditional, simple handshake tattoo** showing two hands is a sign of trust and honesty and a celebration of the power of friendship.

The **handshake tattoo adorned with a peace sign** amplifies the message of the traditional handshake tattoo—the wearer values trust, honesty, and a peaceful life.

The **handshake tattoo with a horseshoe** in the background is a double whammy of luck and prosperity. It can express the hopes that a deal or a promise between two people may be blessed with fortune.

Handshake tattoos, however, can also have darker, more sinister meanings: a **handshake tattoo with a snake biting the hand** is a reminder to not be too trusting and

naive, as there are enough people out there who may exploit your trust.

A **handshake tattoo with a devil hand** is a looker—a fiery red, clawed hand making a pact usually means that the wearer's endeavor will be successful in the near future, but it'll come at a price . . . possibly a soul. Is the devil handshake tattoo a warning to not make devilish pacts? Or, as with so many traditional tattoos, does it ridicule fear of the devil? Only you can decide if you get one!

Handshake tattoos with bone hands are a more recent phenomenon and technically not traditional, since they most often look realistic. Still we include them as a potent reminder that everything is finite.

Whichever handshake tattoo you end up getting, it'll make a statement. I believe we can all shake on that!

"I LOVE MOM"

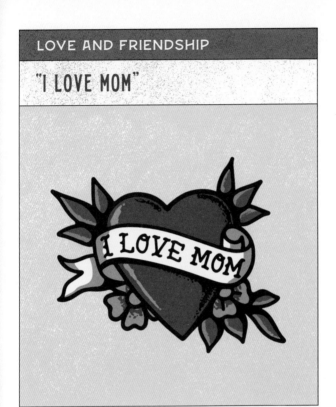

One of the most iconic and recognized tattoo motifs is the "I love Mom" tattoo, sometimes called "mother tattoos." At the core of the design is a red heart with "MOTHER" or "MOM" inscribed in it. Sometimes the word is on a white banner, a scroll, or a dagger. There are, of course, countless options for embellishment—for example, the

heart could be cracked, have an arrow through it, or be surrounded by flames or flowers. Or a swallow could be carrying the banner in its beak. A malleable motif, it also can be easily incorporated into other, already existing tattoos. The bold lettering, popping red color, and clear black outlines make it an eye-catcher and an eternal classic.

Legend has it that 19th-century Irish sailors were among the first to sport the tattoo, inspired by a folk song "The Rocky Road to Dublin," which described the adventures of a man who "kissed [his] darling mother" before leaving his hometown. As with many other traditional American tattoos, Sailor Jerry is said to have popularized it in the 20th century; his "I love Mom" flash certainly is iconic.

The sentiment of the tattoo is universal—the expression of love, kinship, and connection, especially if far away from loved ones. Mother tattoos can also have a patriotic meaning, showing allegiance to the motherland. Indeed, they are most popular among members of the armed services today, especially those serving overseas. Scholar Karin Beeler points out the gendered nature of the tattoo—the idealized mother figure is elevated

to saintliness, while the wearer shows himself to be an adventurous spirit, leaving his home for adventure. The mom tattoo has made it into pop culture as well, including being prominently featured in the very first episode of *The Simpsons*. While Bart imagines his mother's reaction to be joyful and impressed with his mother tattoo ("It makes you look so dangerous," he pictures her saying), Marge stops the session midway and ends up spending the family's savings on laser removal.

While they were originally associated with outlaw masculinity, mother tattoos are now popular with men and women alike as the popularity of tattooing in mainstream culture has grown. The design also has been expanded, sometimes to mom *and* dad or simply to a loved one's name. All this is a testament to its enduring message.

And what's not to like? We're wearing our hearts on our sleeve.

ROSES

With fossils stemming back to the Oligocene Epoch (23–39 million years ago), roses have a long history. And throughout that history, they have been associated with deities, such as the goddess Venus for Romans or the Virgin Mary for Catholic Christians. Yet, its meaning has stayed constant—love, beauty, and passion.

Many people wearing a red rose tattoo add a banner or a heart featuring a loved one's name. The color of the rose also affects its meaning. To celebrate friendship, many people get matching yellow rose tattoos. Pink rose tattoos are lighter in color than the traditional red, but they convey joy, friendship, and femininity, which is why they are often chosen by women.

Another way to modify your design is to add a thorny stem to the red rose, symbolizing not only love and devotion, but also the possibility of pain. A dagger and a rose can tell a tale of love and betrayal, and a skull and a rose can be a promise—that your love only ends with death—or a warning.

Because of its popularity, the rose tattoo itself has become part of our cultural memory, from Tennessee Williams's play and several pop music albums and songs named "The Rose Tattoo" to the video game *The Lost Files of Sherlock Holmes: The Case of the Rose Tattoo*. Whatever version of a rose tattoo you get, may you always fall on a bed of roses (minus the thorns)!

DIVING GIRLS

Perhaps not as common as other girl tattoos, the diving girl is still a popular traditional design. It shows, as the name implies, a woman in a swimsuit in the process of diving into the water, her hands outstretched, her body elongated, embodying the sheer joy and grace of a mid-air plunge.

The image of the diving girl can be traced back to the 1920s, when the Jantzen Swimwear Company decided to release a swimsuit for women, advertising their product with the famous "red diving girl"—a young woman in a red bathing suit diving into the water. Before this new swimsuit came to market, women wore textile-heavy garments to preserve their modesty when bathing publicly. These garments, however, proved to be an unwieldy affair. When they soaked up water, movement was almost impossible. Jantzen's swimsuit, on the other hand, offered women the ability to move, to swim, to dive in and actively participate in water sports without feeling shame.

As a tattoo, the bold red of the swimsuit and the elegant pose of the girl form an eye-catcher. So if you're ready to dive into new adventures, celebrate your liberation, and have fun doing so, this diving girl tattoo may be for you!

MERMAIDS

Mermaids have existed in some form or another in tales ranging from the ancient Assyrians and the Nordic sagas to Hans Christian Andersen's *The Little Mermaid* and its Disney adaptation.

Throughout history, there have been sightings of mermaids, most famously by Christopher Columbus—though

most historians agree he probably saw manatees, from far, far away.

For sailors, the mermaid tattoo averted bad luck and protected their journeys. The traditional mermaid tattoo, which had a resurgence thanks to Sailor Jerry, bears resemblance to the pinup, having her breasts covered by long locks of hair or seashells, but not obscuring her seductive nature.

Their half-human, half-fish form embodies the two-fold symbolism of the tattoo: According to legend, mermaids use their feminine beauty and siren song to lure sailors into storms or drag them underwater, a warning that beauty and perdition sometimes come together. In other myths and stories however, mermaids warn travelers of danger. Like other mythical beings, mermaids escape our attempt to put them into categories. Neither completely good nor totally bad, mermaids are more than meets the eye, and whether you love them or not, they demand your respect.

PINUP GIRLS

The word *pinup* was first introduced to the dictionary in 1941, but the concept goes back to the mid-to-late 19th century, when drawings, lithographs, and later photographs of actresses and models posing in a suggestive manner began circulating and were pinned to walls. French postcard and poster designer Jules Chéret, for example,

was inspired by the burlesque dancers of the Montmartre cafés. In the United States, the "Gibson Girl," drawn in various iterations by illustrator Charles Dana Gibson, could be viewed as the mother of all pinups.

Pinups usually depicted women with hourglass figures, wearing revealing or formfitting clothing, displaying a self-assured and playful demeanor. They were considered to be the epitome of beauty and femininity and were idealized by many men as the quintessential ideal woman. The 1950s model Bettie Page is probably the most famous pinup, striking the requisite fine balance between respectable and risqué.

Pinup art became widespread during the two world wars. Images entertained lonely soldiers and sailors and served as a foil for longing and dreams. Sporting a pinup tattoo was a way to signal masculinity and pay homage to the female form. The traditional pinup girl tattoos featured a young woman with red lipstick, a sailor or soldier's hat—or sometimes a nurse outfit—with flipped-back hair and high heels.

To be sure, the pinup and the pinup girl tattoo have always been controversial. To some, they are an expression

of chauvinism, female objectification, and in the case of the Hula girl, cultural appropriation. Art historian Maria Elena Buszek, however, suggests that pinup art—in whichever form—"has presented women with models for expressing and finding pleasure in their sexual subjectivity." And indeed, today, there is plenty of variation, with pinups wearing everything from cowboy gear to roller skates. They are worn by both men and women, and their symbolism has expanded. As many WWII veterans are no longer with us, some people wear pinup tattoos to remember the greatest generation and their sacrifices.

HORSESHOES

The horseshoe is one of the oldest good luck symbols in Western societies. Roman soldiers already used the so-called "hippo-sandal" to protect the hooves of their horses, since a healthy horse often meant the difference between life and death. Moreover, the open horseshoe reminded them of the shape of a crescent moon, a symbol

for abundance and fertility. In Christian lore, St. Dunstan extracted a promise from the devil to never enter a home decorated with a horseshoe. In Ireland, horseshoes are said to ward off fairies and pixies, who don't like iron. Importantly, the horseshoe needs to be U-shaped, the open part upward. While some trace this practice back to the crescent moon shape, others suggest that luck will "fall out" and leave the home if the horseshoe is not U-shaped.

Like the horseshoe protects the horse from harm and laming, the horseshoe tattoo is there to protect you. It symbolizes good fortune and prosperity all contained in the U-shape. Decorated with colorful flowers, the horseshoe tattoo will stand out and further attract all the good things you want and need in life. Some people will combine their horseshoe with a banner and a name to bring good luck to a loved one. Two intertwined horseshoes can double your luck or stand for luck in partnership.

Just like the lucky 13, the horseshoe also symbolizes the opposite. If you want to signal that you forge your own path in life instead of relying on luck and superstition, the horseshoe tattoo may be turned upside down.

LUCKY DICE

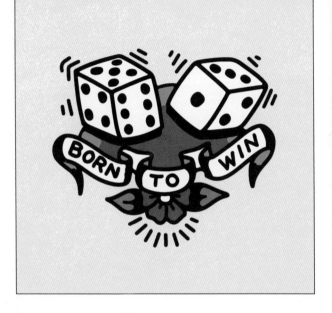

The exact origins of dice are unclear, some scholars suggest that they evolved from fortune-telling practices using knucklebones. Some of the earliest dice were found in today's Iran, dating back to around 2800–2500 BCE. But today's playing dice most likely go back to the Romans: As the Roman Empire expanded, the soldiers' games

came along. They had two types of dice, the tesserae (small objects with sides numbered from one to six), and the tali (which were larger and inscribed on four sides with numbers).

Nowadays, dice, both cubic and polyhedral, are instrumental in board games, role-playing games such as *Dungeons & Dragons*, and, naturally, gambling. They have made it into idioms, from saying "no dice" when something is unlikely to happen, or "it's a roll of the dice" when you don't know the outcome of something, and situations that involve certain amounts of risk are "dicey."

Dice tattoos generally feature two cubic dice, featuring one or two sides of pips (that's the name of the die's black dots). Stark in their monochromatic simplicity and because they are geometric objects, they sometimes have a hint of black shading along one side to create the illusion of three-dimensionality. Varying in size, they can be a tiny filler or a stand-alone piece, or you combine them with other gambling and luck symbols such as the lucky 13, playing cards, or a banner featuring a motto.

Just as with card tattoos, you can personalize them to make them your own. The pips could be a birthday or

another significant date or could showcase your lucky number. The infamous "snake eyes" are a common tattoo, featuring a pair of dice with a value of one on each die (a total score of two being the worst outcome possible in most games). Wearing this tattoo is to protect you from exactly this bad luck! In general, dice tattoos are symbols of luck, a reminder of the unpredictability of life, and an encouragement to take risks. Who knows? May Lady Luck be on your side!

LUCKY 13

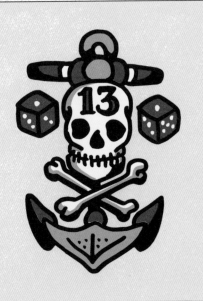

Triskaidekaphobia—a condition known to writer Stephen King and FDR—is the fear of the number 13. The superstition of 13 being an unlucky number is deeply embedded in most Western cultures. Some office buildings don't have a 13th floor. And Friday the 13th is not just the name of a horror franchise; to many it is an unlucky day.

The origins of 13 as an unlucky number are unclear. Some scholars trace it back to Nordic myth, when 12 of the gods met and trickster god Loki appeared uninvited. A nasty plot to kill another god unfolded, which triggered Ragnarök, the end of the world. During the biblical Last Supper, Jesus is gathered with 12 apostles. Even the Grimms' fairy tale *Sleeping Beauty* had 12 good and one evil fairy. But in other cultures, the number 13 is considered a symbol of good luck and abundance. In Italy, 13 people at a dinner table can mean good luck. In France 13 used to be a lucky number. And in Cantonese-speaking areas, the number 13 sounds similar to the phrase "sure to live."

The lucky 13 tattoo can symbolize both good and bad luck. You can wear it as a charm to fend off bad luck or designate it as your lucky number. Traditionally, lucky 13 tattoos were also used to boost one's status as outsider, to make fun of societal superstitions. Most often combined with other symbols of luck, the lucky 13 tattoo can grace the cover of a playing card, be on top of a banner, or sit at the base of a skull. Sometimes the numbers are outlined and filled with colors, but black is the most common.

PLAYING CARDS

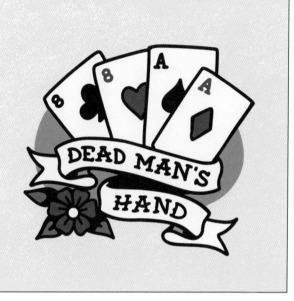

One of the oldest ways to pass the time, playing cards can be traced back to the ninth century CE, with the earliest card decks featuring numbers and suits tracing back to the 13th and 14th centuries. Although playing cards and gambling may not have the best reputation, they have left their mark on us. From proverbs to pop culture in the form of

songs, poems, stories, and novels, playing cards have been part of our lives and have even become a metaphor for it—even if it's a challenge to learn how to play them.

With their simple design, they are also among the most versatile traditional tattoo motifs.

In general, they symbolize luck and the thrill of gambling. Who knows what you may draw next? It's also a good reminder to make the best of any situation; you play the hand you've been dealt. Combined with a skull, playing card tattoos have been used as a good luck charm to the wearer.

Depending on what they show, however, playing cards tattoos can be deeply personal. The **ace of spades** alone is the highest-ranking card in several games. A tattoo featuring the ace of spades then symbolizes power, individuality, and leadership. In the context of the Vietnam War (1955–75), the ace of spades was used by U.S. soldiers to intimidate the Viet Cong soldiers, signifying their impending death. **Four aces**, on the other hand—the highest four-card hand and a dream for every player—can mean luck, winning, and a reminder to go for your dreams.

Even rarer than four aces is a **royal flush**. Mathematically improbable, it's an unbeatable hand. As a tattoo, it's a good luck charm, as well as a sign of one's love of poker and that sometimes the impossible may happen.

With or without her court, the **queen of hearts** is also powerful. While Lewis Carroll's Queen of Hearts may be cruel and governed by her passions—which unfortunately also entail decapitations of others—the queen of hearts tattoo stands for love, desirability, determination, and survival—the heart being one of the most important organs in the human body.

Long before the DC villain of the same name, the **joker** was an unexpected game changer in many card games. He's the wild card, but also what makes the game so enjoyable. The joker tattoo may be for you if you're unpredictable, wild, and adventurous, or the tattoo is a reminder of how quickly life can change.

ANCHORS

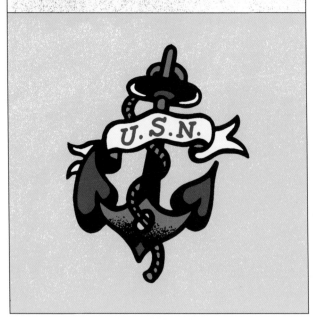

One of the most famous traditional tattoos, the anchor has a long and rich history.

In the early days of Christianity, the anchor was one of the secret symbols people used to convey their beliefs to avoid being persecuted. After defeating the Spanish Armada in 1588, the British Royal Navy adopted the

anchor as its symbol. Over the years, other militaries have done so as well, and today both the U.S. Marine and the U.S. Navy anchor are popular tattoos, showing your steadfast allegiance to both your fellow military members, and to your country. From spinach-consuming adventurer Popeye to the many celebrities with the anchor tattoo, this symbol is one of the most enduring and common tattoos in the world.

A ship's anchor stabilizes and secures it to the seafloor, making it a symbol of endurance. No matter the weather, the anchor will hold your boat steady, so the anchor is representative of loyalty, hope, and protection, which are ideals that not just servicepeople uphold and live by.

Combined with roses, anchors symbolize strong love and loyalty. If combined with a banner and a name, you're letting the world know of your strong connection. An anchor with a swallow, of course, represents a need for both freedom and grounding simultaneously and the balance between the two. In the famous "faith, love, hope" trifecta tattoo, the anchor symbolizes hope.

A "fouled anchor" is an anchor wrapped in ropes. At sea, this is impractical at best, and dangerous at worst. As a

tattoo, the fouled anchor stands for keeping the faith even if times are hard and messy.

Like so many traditional tattoos, the anchor can be adapted to your needs, both in size and color, as well as in endless combinations. We're hooked!

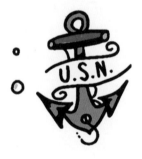

BEACH SUNSETS

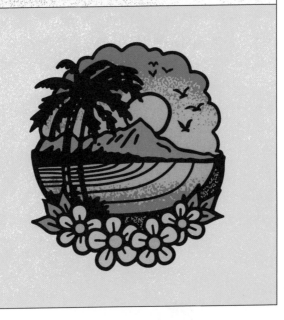

Are beach sunsets cheesy? Maybe. But they are also gorgeous and awe-inspiring. One of the most beautiful of natural spectacles is a beach sunset. Knowing that thousands of people before you and thousands after you have had this incredible experience, yet yours is unique, is a thought bordering on the sublime. Sunsets symbolize

the circle of life—every day the sun will go down and rise again the next.

A beach sunset tattoo is a powerful symbol of hope, renewal, and beauty. They contain three essential elements of sailors' lives—the sun, the ocean, and the shore. In the beautiful combination of a beach sunset, these elements are a declaration of a love of life. Sunsets also stand for finality. The day is over, even if it ends spectacularly. A sunset tattoo is also a reminder of our mortality, yet one that calls on you to enjoy life's simple pleasures. Varying in size, a beach sunset tattoo framed by palms or flowers with striking colors will not go unnoticed.

COMPASSES

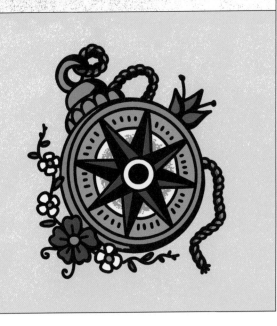

The compass is a tool of explorers and adventurers and stands for the love of travel and the freedom to do so. And metaphorically, when we speak of people who live by a clear set of principles and rules, we call it their moral compass. As such, compass tattoos are perhaps the big brother to the nautical star and possess a similar symbolism. Since

a compass is a tool for navigation, a compass tattoo can mean finding one's way after you've been lost or a sign that you're willing to navigate through life unafraid.

The traditional compass tattoo—or rose compass tattoo—features a circular shape with points or petals radiating outward, each of which corresponds to a cardinal direction. The points can be labeled with their corresponding letters (*N, S, E, W*) or with symbols such as arrows, anchors, or stars. The design may also include decorative elements such as scrollwork, birds, roses, a sailing ship, or of course, an anchor.

The compass tattoo, like the nautical star, is a beautiful and timeless symbol, encompassing both the desire for adventure and exploration and the simultaneous hope for guidance and direction to steer through life's journey.

FLAGS

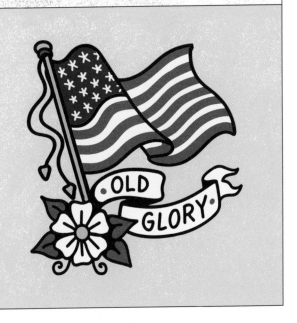

Flags have been a symbol of identity as old as humankind. Their use as tattoos most likely originated for a practical purpose. If you were killed in battle or lost at sea, a tattoo with your flag—together with other identifiers—could be used to put a name to you. Less morbidly, sailors also used flag tattoos as a souvenir of the places to which they

had traveled. As Lyle Tuttle once said: "Tattoos are travel marks, stickers on your luggage."

Flags are also a symbol of togetherness and home. You can combine your flag tattoo with other elements, making your message even stronger. An eagle flying with the American flag in its beak stands for pride, vigor, and freedom—i.e., American values.

A pinup girl wrapped in a U.S. flag is reminiscent of WWII entertainers, but also points to a long-standing association of countries as female and in need of love and protection.

Two different countries' flags crossed at the pole in the background or paired with shaking hands in the foreground may be a political statement, such as of the long-standing friendship between Great Britain and the United States, but many U.S. citizens also use this symbol to highlight and celebrate their ethnicity, such as Italian Americans or Irish Americans, for example.

LIGHTHOUSES

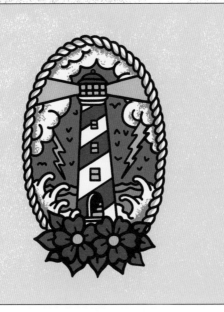

One of the oldest symbols of guidance and hope, lighthouses mark dangerous coastlines, warn of storms, and safely lead ships into harbors. With more sophisticated navigation technologies, lighthouses are not as common anymore, but they are by no means obsolete. In fact, the Tower of Hercules lighthouse in A Coruña,

Spain, dates back to the second century CE and remains fully functional.

As a tattoo, the lighthouse expressed the wish and hope to return home safely for sailors and servicepeople. A lighthouse guides ships and travelers through the night and choppy waters; a tattoo of one may act as a symbol of hope if you have gone through dark times. In a way, the lighthouse tattoo is a secular version of the **Rock of Ages tattoo** (see page 106). If you combine it with an anchor tattoo, the protective value of the lighthouse is emphasized—you'll find your way.

Connected to the earth, withstanding wind and weather, the lighthouse also symbolizes quiet strength and leadership. It will not budge. If those are qualities you possess—or desire—a lighthouse tattoo, perhaps embroiled in a storm or with crashing waves, is a powerful way to show this.

You may want to combine the lighthouse tattoo with a beach sunset. A colorful, especially positive tattoo, it offers the hope and guidance of the lighthouse with the beach sunset's promise of a new day.

NAUTICAL STARS

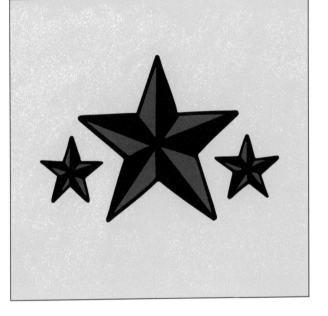

Perhaps the quintessential sailor tattoo, the nautical star is five-pointed, with alternating colors of black and white or red and white. Each of the star's five points represents a different cardinal direction—north, south, east, west—and the center point as the intersection of the four directions. Nautical charts—at least those in the Northern

Hemisphere—use the North Star, represented as the nautical star on maps, to indicate true north on a compass as a guidance.

The North Star has found entry into our language, too. People sometimes refer to their purpose in life as their North Star. It is unsurprising then, that sailors used the nautical star as a symbol for finding one's way back home—in the olden days of crossing the oceans this was not always guaranteed. For the nonsailors among us, it can mean protection on your path; a reminder to not lose sight of your purpose, dream, or goal; and staying true to yourself.

But the nautical star has taken on other meanings as well over the years. According to historians Elizabeth Lapovsky Kennedy and Madeline D. Davis, lesbians in the 1950s wore a nautical star on the top of their wrist, so that they could cover it up during the day with a wristwatch.

While the nautical star has become popular, its original fan base remains. It is to this day one of the most popular tattoos within the U.S. Navy, the U.S. Coast Guard, and the U.S. Marines, as well as other people working out at sea.

Nautical star tattoos are a deeply meaningful tattoo if you want to start small. You can always adorn it with other symbols, but it speaks for itself. The classic black-and-white color scheme will stand out in its stark simplicity or you can use a color (like red) to make your tattoo pop. A banner with a name or a phrase will underscore the symbolism of your tattoo.

May you always find your way!

SAILING SHIPS

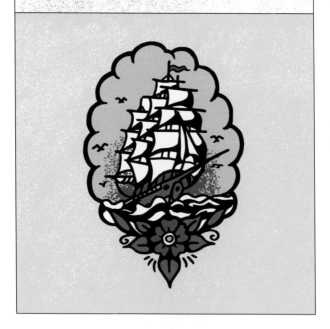

The sailing ship, with its several masts and staggered sails, is deeply connected to the Age of Exploration (15th–17th centuries) when European powers set out to enlarge their influence on other parts of the world. To a sailor, the sailing ship is the home away from home, symbol of their lives' transience—they belong to neither the land nor the

sea. It is also a symbol of adventure. From fighting the elements to bad morale and from rotten food to pirates, there were—and are!—plenty of dangers associated with seafaring. The sailing ship is a protective tattoo for sailors hoping for a safe journey, especially when connected to other good luck symbols, for example, if it is inside a horseshoe. Together with a setting sun, birds, and blue waves, the sailing ship tattoo also symbolizes the means and joy to travel, explore, and roam. Sporting a sailing ship may also tell others that there is more to you than just the surface—the ship may be alone at sea, but there are a lot of people on it that make it work.

Some of the most famous sailing ship flash were created by Sailor Jerry, who ensured that his art was technically accurate down to the last detail.

CROSSES AND THE ROCK OF AGES

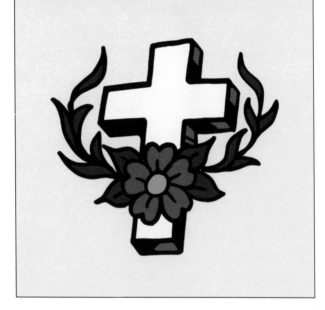

One of the oldest symbols of Christianity is, of course, the cross. Featured in 2,000 years of artwork and various cultures, crosses are signifiers of faith. But a cross tattoo can be more than that. Since crosses also mark graves, a cross tattoo can also be a memorial, especially if you add a name or decorate it with flowers. It can stand for devotion and

sacrifice to your cause or to your faith—emulating Jesus's sacrifice. Some choose to add angel wings to the cross, creating a truly striking image and one to protect you, like a guardian angel would.

Albert Parry recounts an anecdote in his book of a Jewish couple complaining to the New York Society for the Prevention of Cruelty to the Children in 1902 that their underage son had gotten tattooed. The tattoo was less of an issue, but that he chose a crucifix upset the parents. Sometimes, a cross tattoo can also be a symbol of rebellion.

A special variation of cross tattoos is the famous Rock of Ages. In 1763, English preacher Augustus Toplady was caught in a storm and found refuge in a gorge, surrounded by rocks. Inspired by his near-death experience, he wrote the famous Christian hymn "Rock of Ages." The image associated with the design, however, goes back to German American painter Johannes Oertel's 1876 artwork, in which a person clings to a cross-shaped rock, surrounded by stormy waves.

It is a powerful symbol, especially to sailors who experienced both the literal and the metaphorical storms the

hymn and painting reference. Rock of Ages tattoos are usually large-scale back pieces, often adorned with other Christian imagery, such as angels, or nautical elements, such as a sailing ship or sunsets—sailors again combining their daily life with their faith.

SKULLS

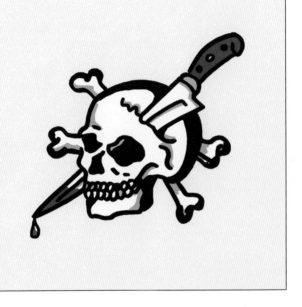

The marvelous 2019 documentary *Tattoo Uprising* contains an interview with German auteur filmmaker and general badass Werner Herzog on the set of his 1982 film *Fitzcarraldo*. He describes getting his first tattoo—a skull in front of a microphone—from "Ed Hardy, a master of his trade." Herzog doesn't elaborate on the personal meaning

of his tattoo but concludes the interview with this advice, "You shouldn't have your body tattooed, without at least one death."

Whether you agree with his assessment or not, Herzog's quote shows how significant skull tattoos are. Human or animal skulls were used in many cultures to celebrate or even communicate with a deceased family member or friend. A skull tattoo—with or without an added name, perhaps flowers, or even a heart—can be a memorial, making it clear that you'll never forget your loved one.

A skull representing death reminds us all of our mortality. For sailors, or those in the armed forces, a skull tattoo can have a protective meaning and one of bravery. You're telling death that you're aware of him and you will fearlessly do what you came to do anyway. It is also a reminder of mortality and tells us to enjoy life every day.

Skull tattoos are also associated with biker gangs, for whom it stands for the adventurous lifestyle and possibly a way to intimidate rivals.

You can modify the meaning of your skull tattoo in many ways. Combine it with banners and phrases, such as "only the good die young" or "live free or die," and you

wear your life's motto on your sleeve. Add snakes and bones, and your skull tattoo can be a protection from and warning to your adversaries. Accompanied with roses, birds, and hearts, it can be a monument to love and affection. Perhaps Werner was right after all, and everyone needs at least one skull tattoo.

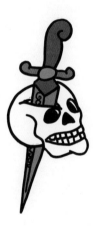